BOX WORLD

Adventures

Building Crafty Cardboard Projects

By Suzy Ultman

D1426341

CHRONICLE BOOKS

SAN FRANCISCO

• INTRODUCTION •

Welcome to Box World! Pack up your imagination (and a change of underwear) and set course for a boxy adventure. No passports needed—just an old carton or box, your trusty scissors, gobs of glue, and a playful attitude. Now you are ready to travel to Box World.

With these creative projects, you will give a box a second life. Before you toss that cardboard treasure into the recycle bin, imagine the possibilities. Take a close look at your box—its quirky dented side, its stamped body, its floppy lid. You might notice that it's yearning to become a skyscraper, a windmill, or a safari jeep. With the ideas and materials in this book, you can create an entire city, set up a small scene, or build a single box for display. Make a difference to the environment while learning about our neighbors around the world.

Box World Adventures guides you through 15 projects from 11 vibrant countries. The colorful art sheets in this portfolio are packed with architectural details, local landmarks, charming pedestrians, and indigenous flora and fauna patterns to decorate your box. For an easy start, try your hand at Big Ben or the Great Wall. It only takes a couple of boxes and some basic cutting skills and you're on your way to building one of these monuments. The pagoda and Saint Basil's may take more time, but they're worth the trip.

On rainy weekends, my boys and I dig through the box pile, imagining the possibilities the day of constructing will bring. My oldest always seems to have the tallest building, while my youngest enjoys sprawling structures. I used to captain these playful excursions, but lately, I'm just along for the ride.

So, gather your supplies and start your adventure to the four corners of Box World.

Bon Voyage, *Suzy*

TOOL KIT

FOR CUTTING:
- sharp scissors for heavy cutting
- X-Acto knife for detailed cutting

FOR STICKING & ATTACHING:
- quick- and clear-drying glue (Nori is my hands-down
 favorite. It is available at most art stores.)
- double-sided tape for milk cartons and other coated boxes
- clear packing tape to secure box flaps
- brads of different shapes, sizes, and colors
- needle and thread

FOR BUILDING & CONSTRUCTING:
- ruler
- burnisher or bone folder
 (This paper-crafting tool is optional but it is really helpful for scoring
 and affixing papers. It can be found at most art or craft stores.)
- circle template
 (You can also trace around drinking glasses, but nothing compares
 to the options and ease of a template.)
- box
 (I have suggested sizes for each project, but don't be afraid to think
 outside the box and choose your own.)

FOR DECORATING:
- pack of multicolor construction paper
- colored pencils and pens
- colored artist/masking tapes
- washi tapes (Japanese patterned-paper tapes, available online)

DIRECTIONS

1

PICK A BOX

Go to your box stash or recycling bin and choose a cardboard companion. Every box or carton has its own personality. Look for barcodes that you can cut around to make windows and doors. Flaps can be roofs, doors, or awnings. Choose a white or a brown box. As for size, I give specific dimensions for each project, but you can always use a box with similar proportions. For some projects, I wanted to start with a clean slate, so I turned the box inside out. It's a simple process: (1) carefully detach the glued seam, (2) refold the box with the blank side facing out, and (3) close the box with packing tape. Finally, decide how the box will stand. I suggest cutting off the bottom flaps, along the fold, in a clean, straight line. Your box will have less wobble than if you tape the base flaps.

2

MEASURE, CUT & GLUE

Measure your box. Cut the desired pattern pages from this portfolio and/or construction paper sheets to fit the sides and flaps of the box. Glue those sheets like you mean it. If you have a burnisher, give the paper a loving rubdown. While the box is drying, cut any additional structural pieces—like windmill blades, the Empire State tower, or pagoda mokoshi (roofs). This is also a good time to cut out any additional items that will accompany your box—lanterns, birds, flowers, and so on.

DECORATE

Using the sticker sheets and pages of art, add faces, windows, and other architectural details. But, don't stop there . . . have fun with your favorite art supplies or kitchen goodies like glitter, origami paper, milk caps, and straws.

DISPLAY & PLAY

Finish the scene with happy pedestrians, friendly critters, and colorful landscapes. Your action figures, dolls, and plastic animals will be thrilled to have new homes and structures for playtime. Your little green soldiers are at the ready to advance on the Great Wall. If you're too old for playtime, display your scene. My windmill sits front and center in my entryway, happily greeting visitors with a smile, a wink, and a spin of the blades.

UNITED STATES
EMPIRE STATE BUILDING

Materials Needed:

- one extra-long aluminum foil box
- glue
- colored paper
- dry beans
- washi tape, silver
- black marker
- toothpick

You don't have to take a taxi all the way to 5th Avenue and West 34th to see the Empire State Building. You can make your own! This skyscraper is constructed from an extra-long aluminum foil box, turned inside out. To balance the 102-story structure, pour dry beans into the box. (A couple of inches at the base should keep your building standing strong.) Use silver washi tape and architectural trims to create the visual levels of the building. Next, draw the 6,500 windows with a thick black marker. On the tippy top, attach a plastic stir stick antenna, and on the very bottom, add the "empire state" doorway. With more foil boxes, you can create a New York City block complete with pizza shop and a big apple.

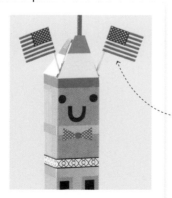

Making a flag is so easy!
1. Grab the flag sheet from the portfolio's set of patterned papers.
2. Cut out the country's flag.
3. Wrap around a toothpick.
4. Double-stick tape or glue.

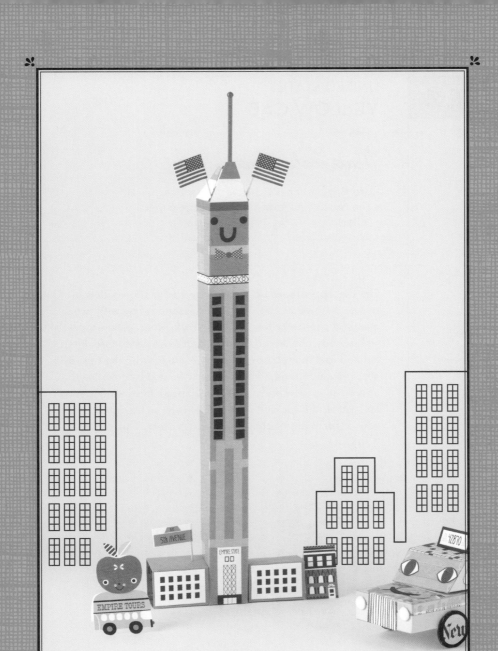

UNITED STATES
YELLOW CAB

Materials Needed:

- two mac-and-cheese boxes
- *The New York Times*
- yellow tape
- two white brads
- cardboard
- white paper
- scissors
- glue

The Big Apple looks better than ever from the window of this cheesy yellow cab. Start your assembly line with two mac-and-cheese boxes, *The New York Times*, yellow tape, white brads, checkered borders, and extra cardboard. First, cut and fold the top box at an angle. Next, wrap the desired areas in yellow tape. (Try a different version by covering the entire cab in newsprint.) Cut the windows from white paper and attach the sticker face parts. Finally, pick a driver from your assortment of characters and critters. This cab is "On Duty."

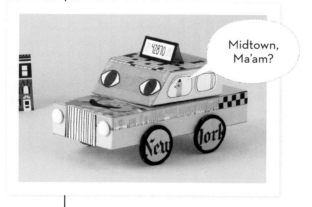

ENGLAND
DOUBLE-DECKER BUS

Materials Needed:

- cereal box
- red tape
- cardboard
- white and black paper
- glue
- colored markers or pencils (optional)

Lords and Ladies—are you heading to Parliament Square for some sightseeing? Hop aboard the cheery number 5! To create this dapper British bus, grab an empty cereal box. After carefully ungluing the seams, turn the container inside out. After applying red tape for the graphic accents, add cardboard wheels and cut paper windows. Next, stick on the face, the bus sign, and the number from the portfolio. Now, your bus has a ticket to ride. Try different-sized boxes to create an entire fleet of buses. This project promises to be a jolly good time.

If adding details to elements made out of black paper, try using a white pencil or pen!

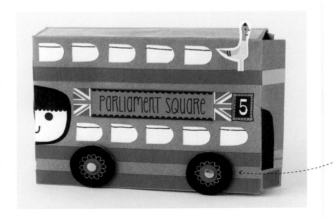

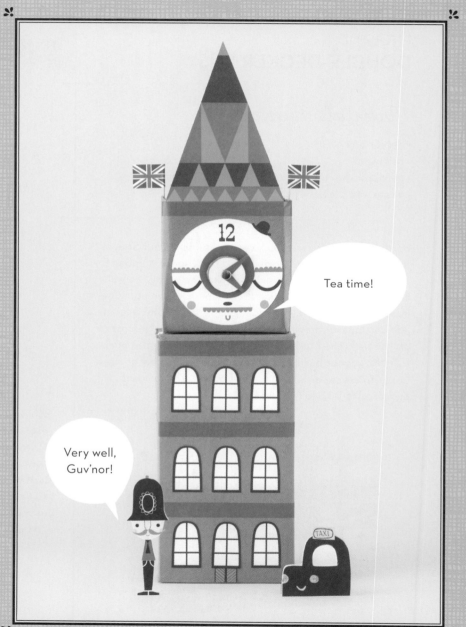

BIG BEN

Materials Needed:

- one 6 x 6 x 6" box
- one 6 x 6 x 12" box
- scissors
- colored paper
- glue
- cardboard
- brad

With your own Big Ben, you'll never miss high tea again. Create this world-famous timepiece using two standard boxes: one 6 x 6 x 6" box for the tower and one 6 x 6 x 12" box for the building. Using the large-geometric-pattern paper from the portfolio, cut two identical, triangular roof pieces, and sandwich them around the front flap of the tower box. Repeat for the back flap. After the paper dries, trim the box flaps along the triangle. Then, add windows, flags, and pigeons. The moving clock face is created by simply attaching a cardboard circle to two paper clock hands with a brad. Tic toc!

SCOTLAND
CASTLE

Materials Needed:

- one Pop-Tart box
- one aluminum foil box
- colored paper
- tape

- scissors
- colored markers, various colors
- toothpick

Follow the merry bagpipe music and you'll find Lochnaw Castle nestled in the Scottish Highlands. This miniature version is built using a Pop-Tart package and an aluminum foil box. Unglue the edges of each box and turn the boxes inside out. Before you retape the tower closed, cut the detailed roof line. Now you are ready to adorn the castle with brick patterns, windows, doors, and banners. The tower is under the watchful eye of the queen. To create this look, combine your drawing skills with cut paper to make your own king or queen face. Finally, show your pride by flying a royal standard atop a toothpick. You could even create a personal family coat of arms!

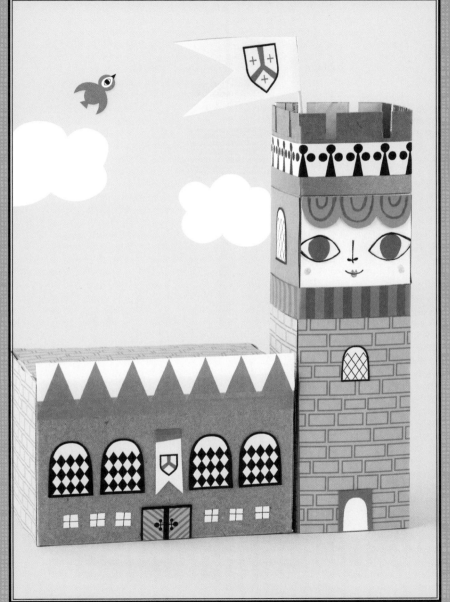

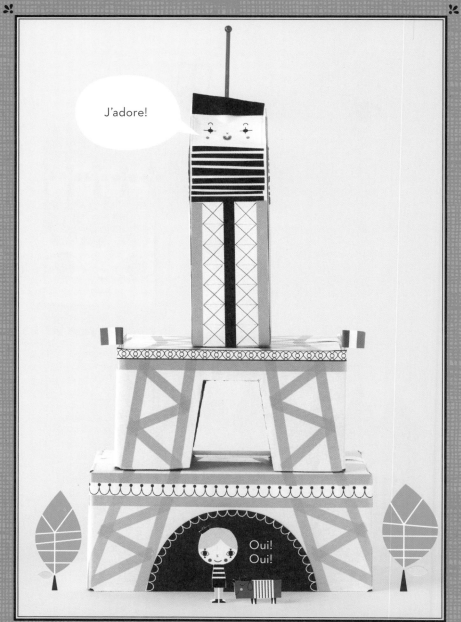

EIFFEL TOWER

Materials Needed:

- one 4 x 6 x 8" box
- one 4 x 6 x 10" box
- one quart-sized milk carton
- washi tape, silver

- plastic stir stick
- black paper
- scissors
- glue
- two toothpicks

If this Parisian mime could speak, he'd say "bonjour, enjoy a croissant, and let's build a boxy tower." The French landmark is constructed with two standard boxes, one 4 x 6 x 8" and one 4 x 6 x 10", and a quart-sized milk carton. Use silver washi tape to create the iconic lattice girders and decorative borders to define the metal trusses. Top the tower with a plastic stir stick antenna. (If you don't have a stir stick, try a pencil or a straw.) Then, add that certain je ne sais quoi that is sure to charm anyone—the mime's body, face, and beret. A face is supplied in the portfolio, but depending on your mood, try drawing your own expressive street performer. Grab some black paper to cut shirt stripes and the beret. Glue, and voilà!

THE NETHERLANDS
WINDMILL

Materials Needed:

- one 7 x 8 x 14.5" box
- glue
- colored markers, various colors
- cardboard
- brad

Enter the fairytale world of Holland with its canals and countryside blanketed in tulips and dotted with windmills. Using a standard box, create the main structure for your windmill. Glue the floral pattern paper from the portfolio to the box, and then add borders and a door. For an entire neighborhood of windmills, use a variety of box sizes, blade shapes, and decorative pattern pages. You can even give each mill a sign, naming it after its famous counterpart in Zaanse Schans, a neighborhood in North Holland with historic windmills such as The Ox, The Cat, The Spotted Hen, and The Cloverleaf.

Are you ready to take a spin?

1. Cut out a large circle and 4 blades from cardboard.
2. Glue the blades to the circle, known as the brake wheel.
3. Using a small screwdriver, poke a hole in the middle of the brake wheel and the spot on the main box where you want to place it.
4. Attach with a brad.

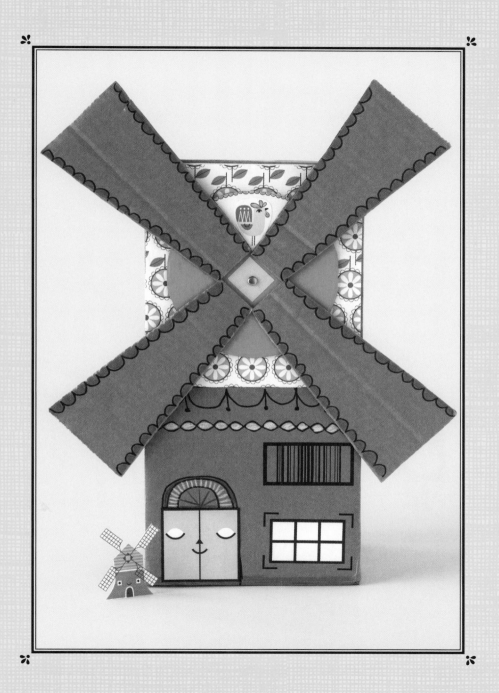

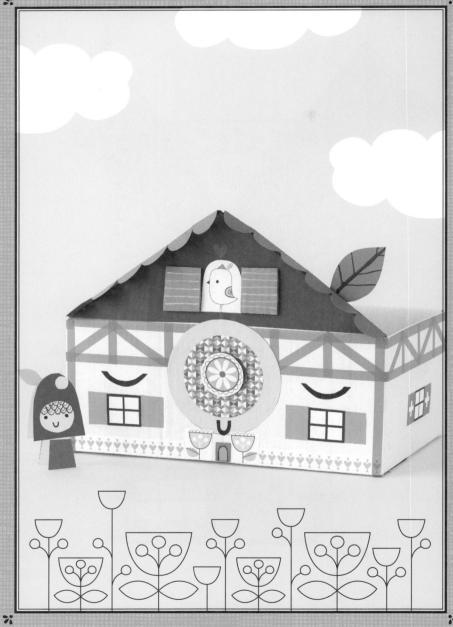

CHALET

Materials Needed:

- one 5 x 10 x 14" box
- scissors
- colored paper, brown
- colored paper, various

- washi tape, any color
 (we used green)
- brad

High in the Alps sits a sweet chalet, keeping a watchful eye over the mountain critters. So, pull out the fondue pot and a 5 x 10 x 14" box and begin your Swiss adventure. Cut the top box flap into a triangular roof line and cover it with brown paper. Create a scalloped roof, and attach it from behind with double-sided tape. (For exact scallop measurements, go to chroniclebooks.com/boxworld to download a free template.) Add architectural details for folksy flair: cut paper shutters, heart borders, windows, and a door. Finish the look with sticker face parts, washi tape "beams," and a paper cuckoo bird. For extra fun, create wee cozy matchbox beds to place inside the chalet. This project will have you singing "yo de le hee hoo."

ITALY
ART MUSEUM

Materials Needed:

- one 10 x 7 x 2" box
- construction paper
- one aluminum foil box

For your first stop in "the floating city," hop aboard a gondola heading straight to the Venetian Museo. The simply sweet structure has colors reminiscent of Italian gelato—pistachio and strawberry, delicious and beautiful! Use a standard book-sized shipping box, 10 x 7 x 2", with the flaps facing forward. First, cover the box front with construction paper. Then, decorate the museum with a welcoming entryway, pointy windows, and gothic ornamentation. Finally, add a balcony built from an inside-out aluminum foil box. When you're finished, swing open the front doors and fill the interior with your own gallery of mini masterpieces. It's a boxy renaissance. Bellissimo!

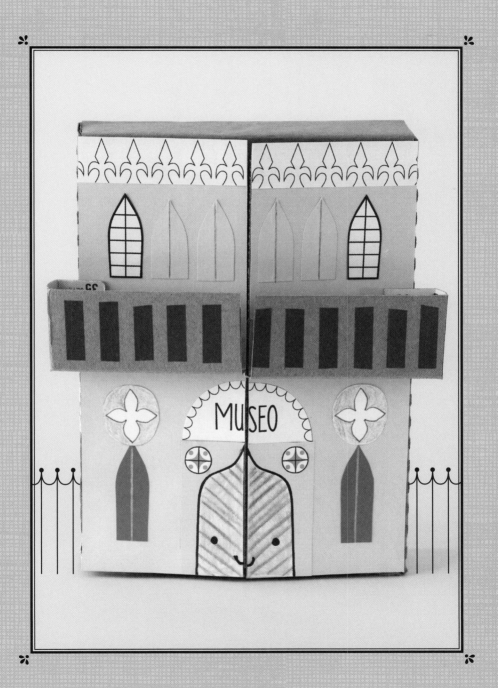

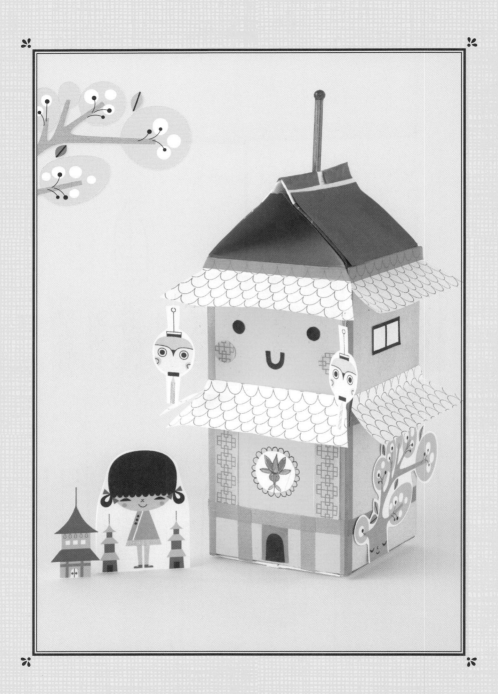

PAGODA

Materials Needed:

- one gallon milk carton
- construction paper
- double-sided tape
- washi tape

Your fortune cookie says, "Today is your lucky day. You will build a pagoda." So get cracking on your own darling tower. This sunshine and crimson pagoda starts with a gallon milk carton base. Affix your colored construction paper with double-sided tape. (Note: Glue will bubble and buckle due to the waxy package coating.) Add roof pieces, architectural borders, washi tape beams, and face stickers. The hand-strung paper lanterns add a whimsical touch. For thinner or shorter structures, check out your dairy aisle for milk cartons in varying sizes. Using a quart or pint carton will allow you to play with the number of tiers, giving each pagoda an individual feel. You can also try different colored papers and use fortune cookie paper strips for architectural details. This project is heavenly fun.

CHINA
THE GREAT WALL

Materials Needed:

- one 6 x 6 x 6" box
- three (or more) aluminum foil or plastic wrap boxes
- egg carton
- toothpicks

The only thing as great as the Great Wall is building your own. You may not be an emperor, but don't let that stop you from recreating this stone and brick wonder. Use a standard square box for the main watchtower and inside-out plastic wrap or foil boxes for the fortification walls. Use the stone-pattern paper in the portfolio to create the wall texture, and add the sticker face for giant-sized personality. You'll be well guarded with additional egg carton lookouts, topped with toothpick flags. The more foil boxes you save, the more you can use, the longer you can stretch your wall. How would your mom feel about a great wall running down the hallway and into your bedroom?

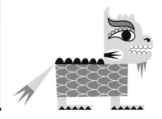

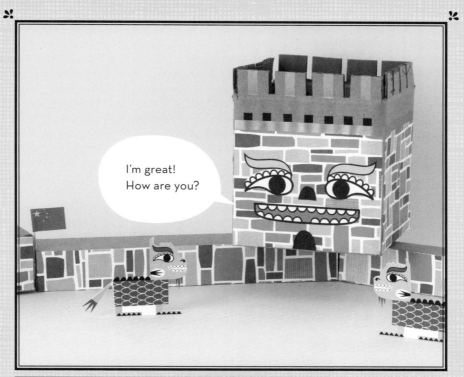

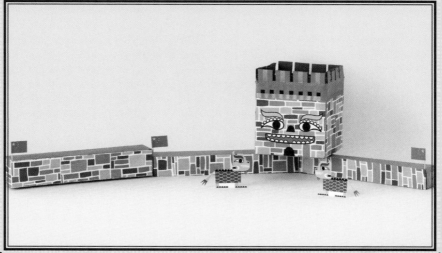

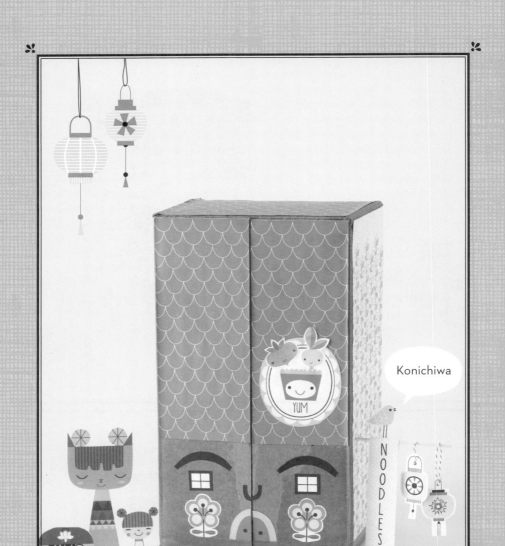

NOODLE HOUSE

Materials Needed:

- one 6 x 6 x 12" box
- glue
- colored paper
- bamboo-skewer

- origami paper (optional)
- sushi "grass" (optional)
- chopsticks (optional)

This joyful noodle house makes a perfect playhouse. Position your box, with the flaps opening forward for easy entrance. Start by gluing the red shingle-pattern paper from the portfolio on the box front and the bamboo pattern on the sides. Add windows, blooming flowers, grass, and a bright doorway. Colorful accents include a bamboo-skewer signpost and hanging threaded lanterns. Customize the "YUM!" sign with your own dish of the day. Cut and paste food ingredients from the provided decorative sheets, or draw your own concoction in the bowl. Add extra touches using origami paper, adding sushi "grass," affixing chopstick beams, or making origami animal customers. I can already hear the slurping of the cold noodles as you serve up fun from this boxy restaurant. Mmmm . . .

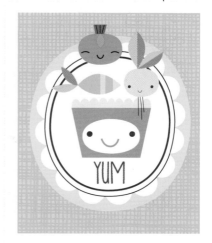

AFRICA
SAFARI JEEP

Materials Needed:

- one matchbox
- construction paper
- corrugated cardboard

- glue
- four brads, silver

Explore the African savanna in this adorable matchbox jeep. Add a construction paper roof, corrugated cardboard details, and oversized silver brads to complete the rugged safari rover. Affix the smiling sticker grill, and this jeep is road ready. Your giraffes will be pleased as punch to nibble leaves from your toilet paper roll baobab tree. Now, your project is really coming to (wild) life.

To make your giraffe's stand, glue or tape a folded piece of construction paper onto the back side of the giraffe.

45°

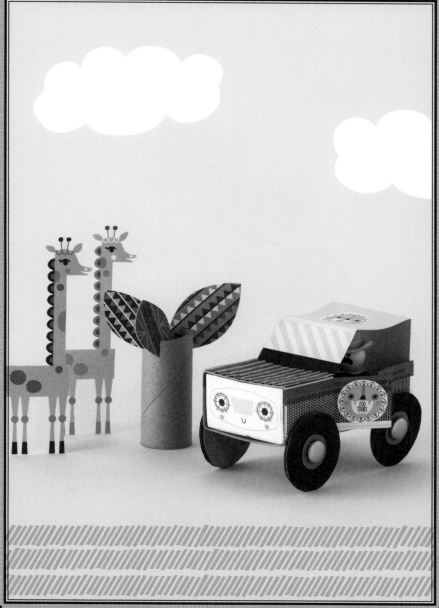

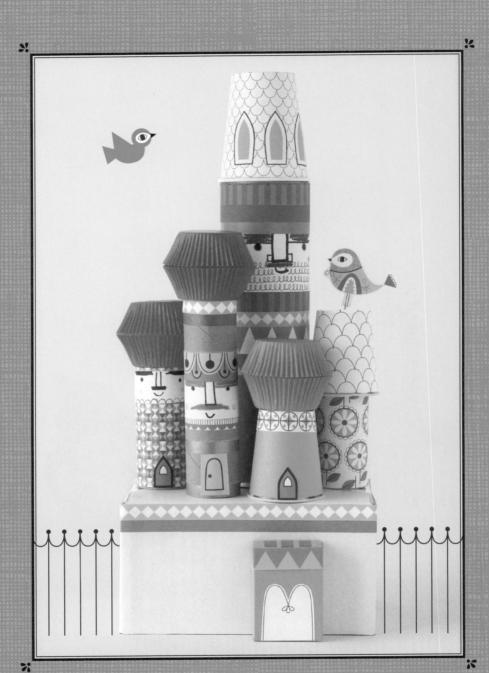

SAINT BASIL'S

Materials Needed:

- one 4 x 6 x 8" box
- paper cups
- cardboard toilet paper and paper towel rolls
- jewelry box
- potato chip canister
- glue
- cupcake liners
- washi tape, various

Is beautiful, da?! Create this colorful combination of domed towers with paper cups, toilet paper and paper towel rolls, potato chip canisters, cupcake liners, and add a jewelry box for the door. Add Russian character by wrapping each upcycled item with geometric or floral prints, architectural trims, and thick-browed faces. Attach doors and colorful tapes and top it off with a babushka-wearing birdie.

Stack cupcake liners on top of each other to form the onion domes.

BOX WORLD
S.S. ME

Materials Needed:

- one cracker box
- one aluminum foil box
- cardboard toilet paper roll
- construction paper
- scissors
- glue
- toothpick

Thar she blows, ready to sail the seven seas in search of cardboard adventures. You'll have a whale of a good time creating this friendly floating fishy ship. Grab a cracker box, an aluminum foil box, and a toilet paper roll to get started. Cut strips of paper scales using construction paper or better yet, vintage maps. After you've attached the scales, create the mouth and eyepatch from cut paper and affix them to the creature. Then, add the mustache, the winking eye, and windows. Decorate the smokestack with a geometric print, colored tape stripes, and a portal window. Fly the colors, adding your own "S.S." and top the boat with an origami sailor's hat. Ahoy!

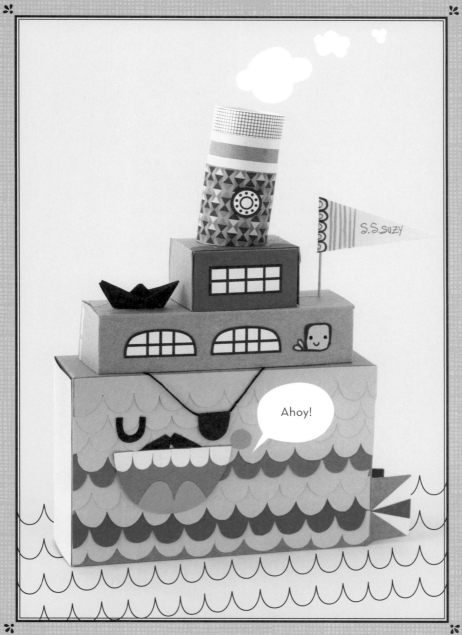

Let this book serve as a guide as you begin your journey into Box World. Before you know it, you'll have the tools to go beyond the pages, building other famous landmarks including your own house, your school, or your favorite ice cream shop . . .

Where else in the world will you go?

Ideas for more *Box World Adventures*:

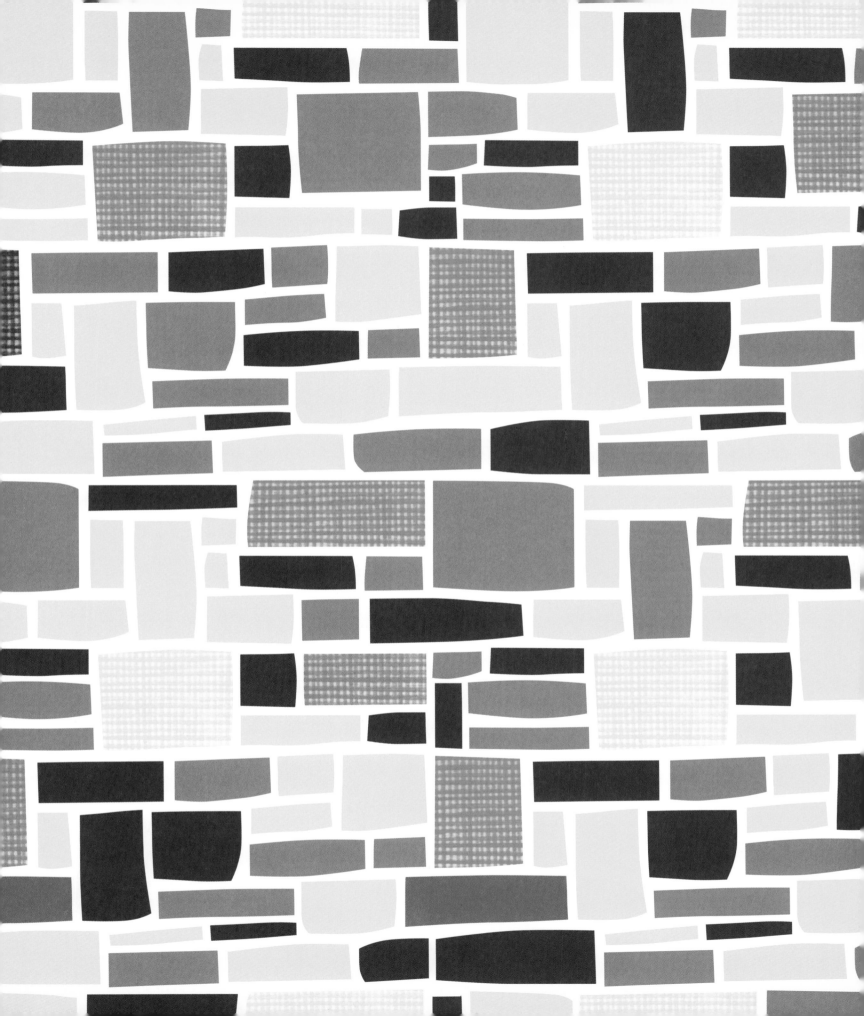

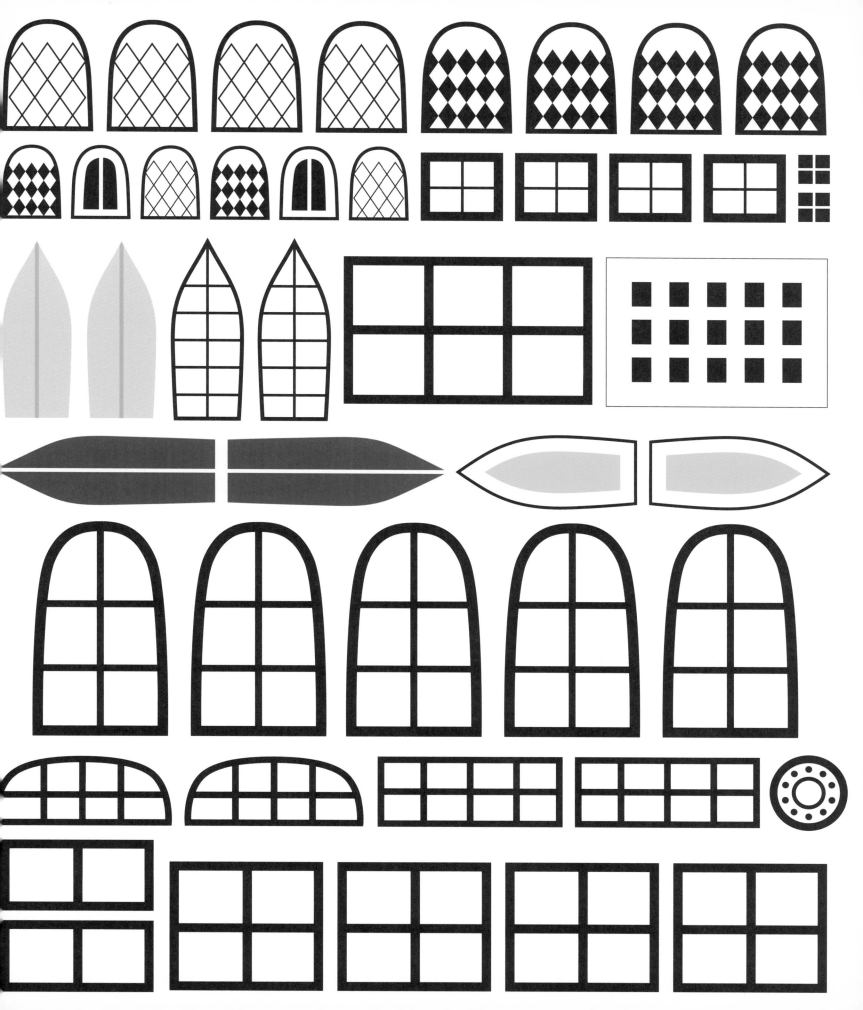

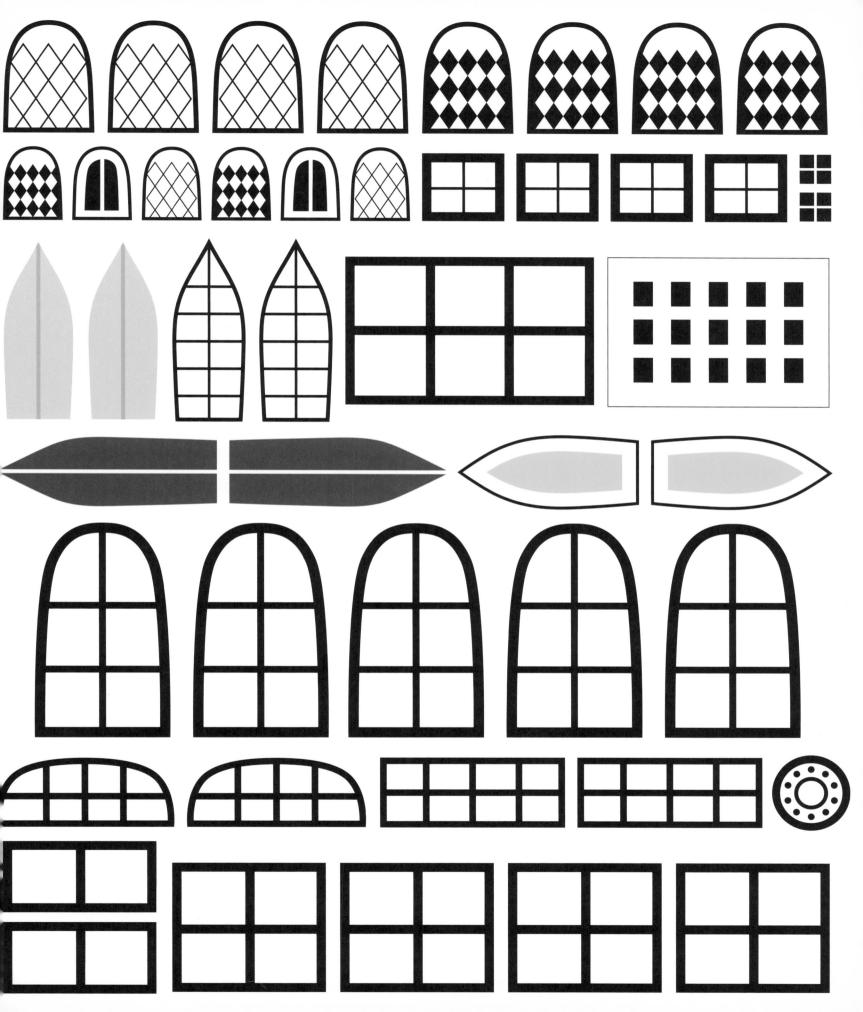

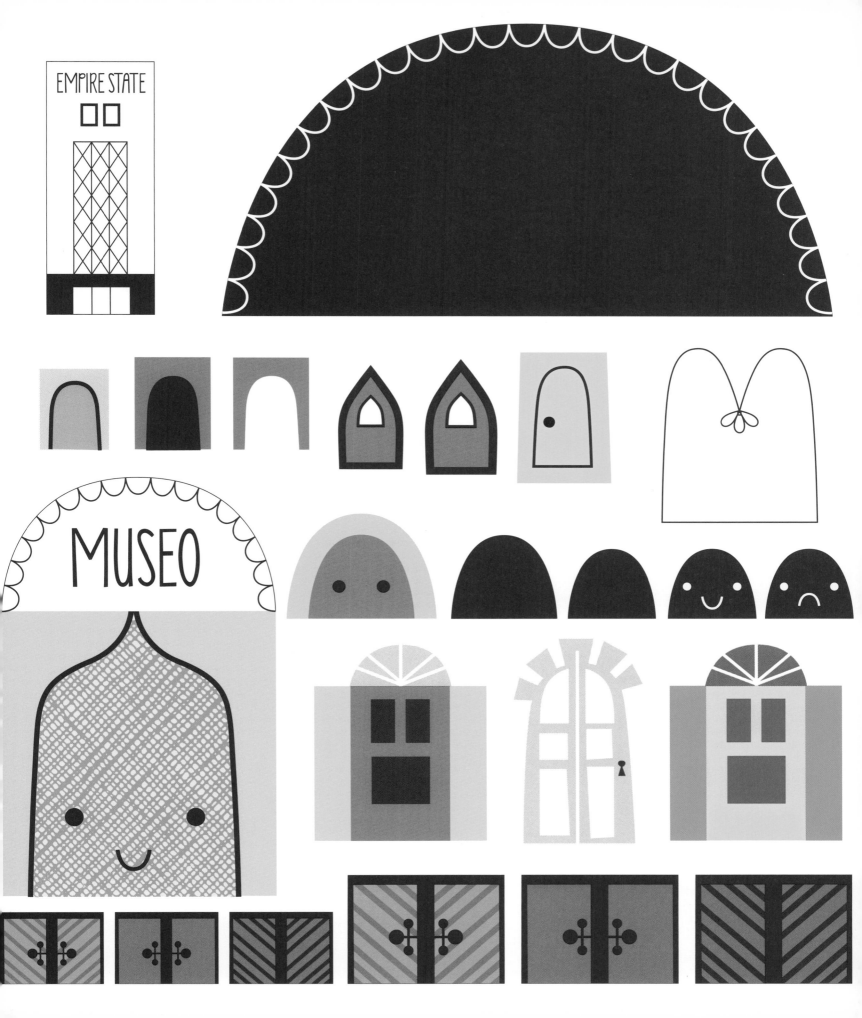

EMPIRE STATE

MUSEO

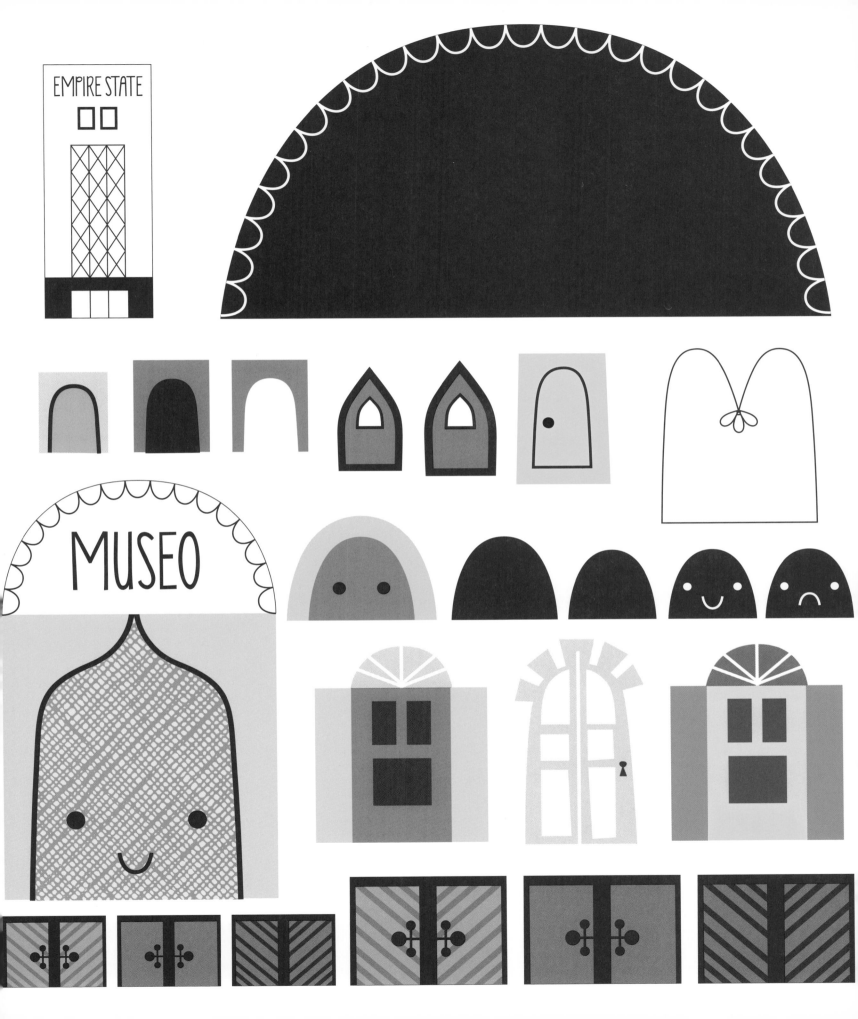

EMPIRE STATE

MUSEO

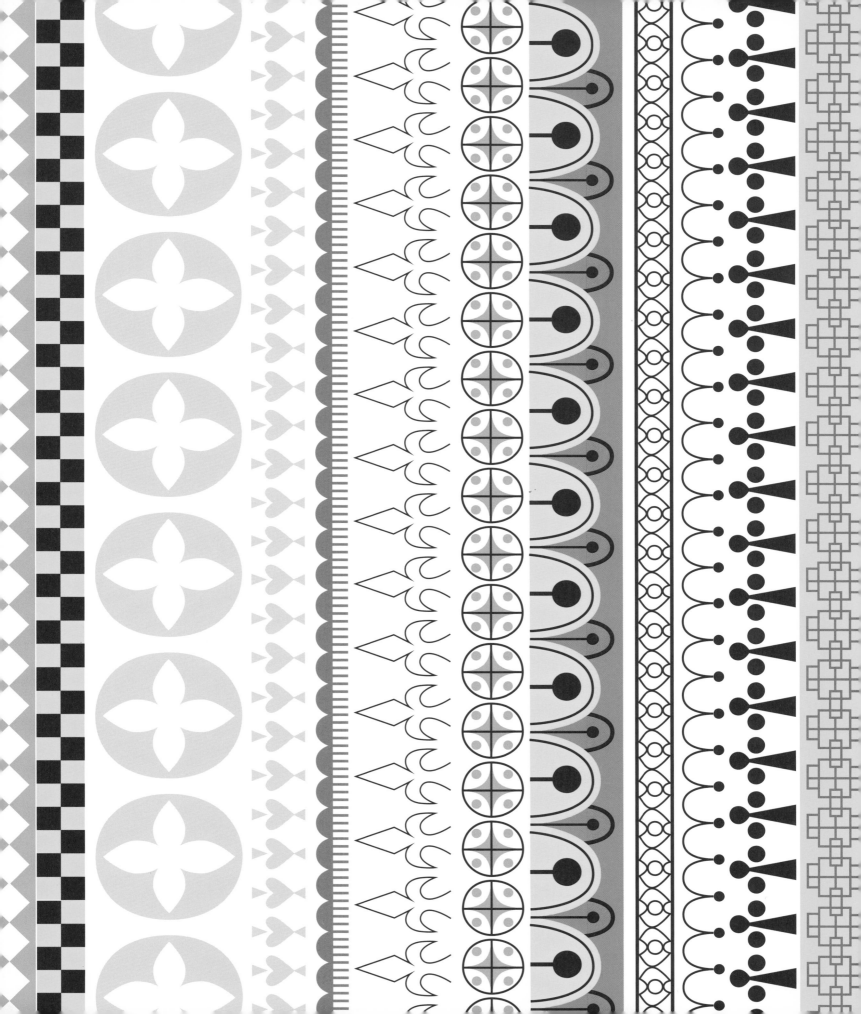

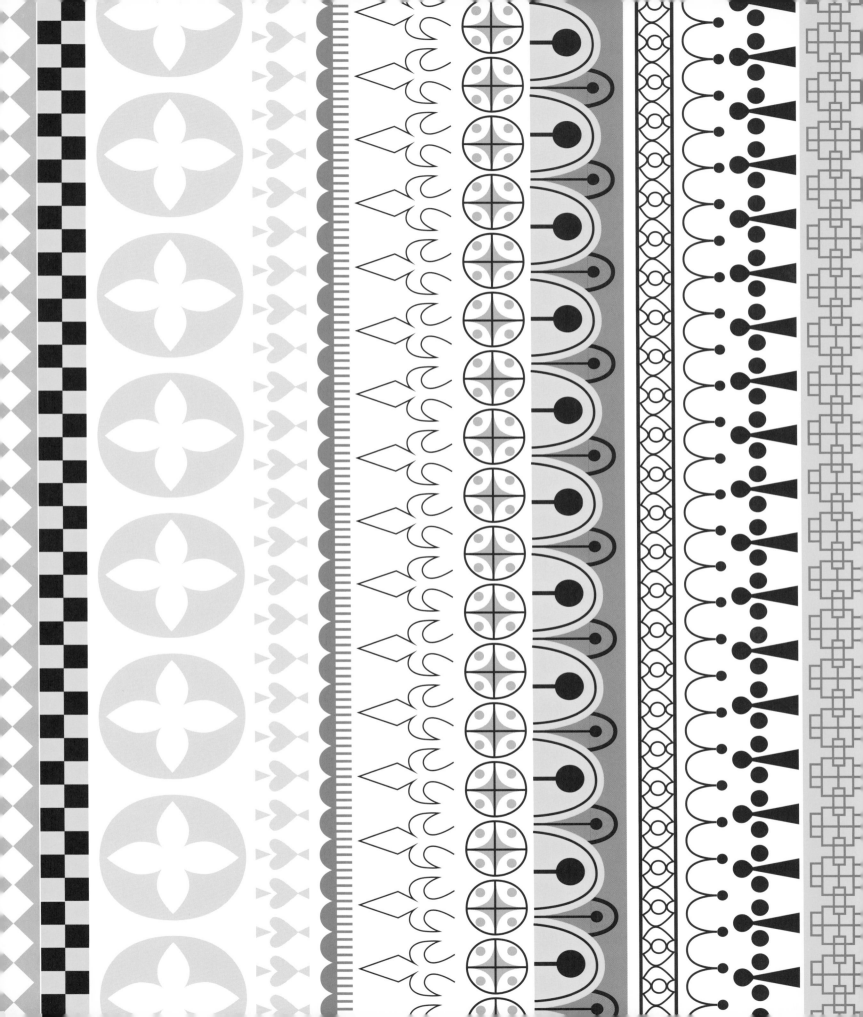

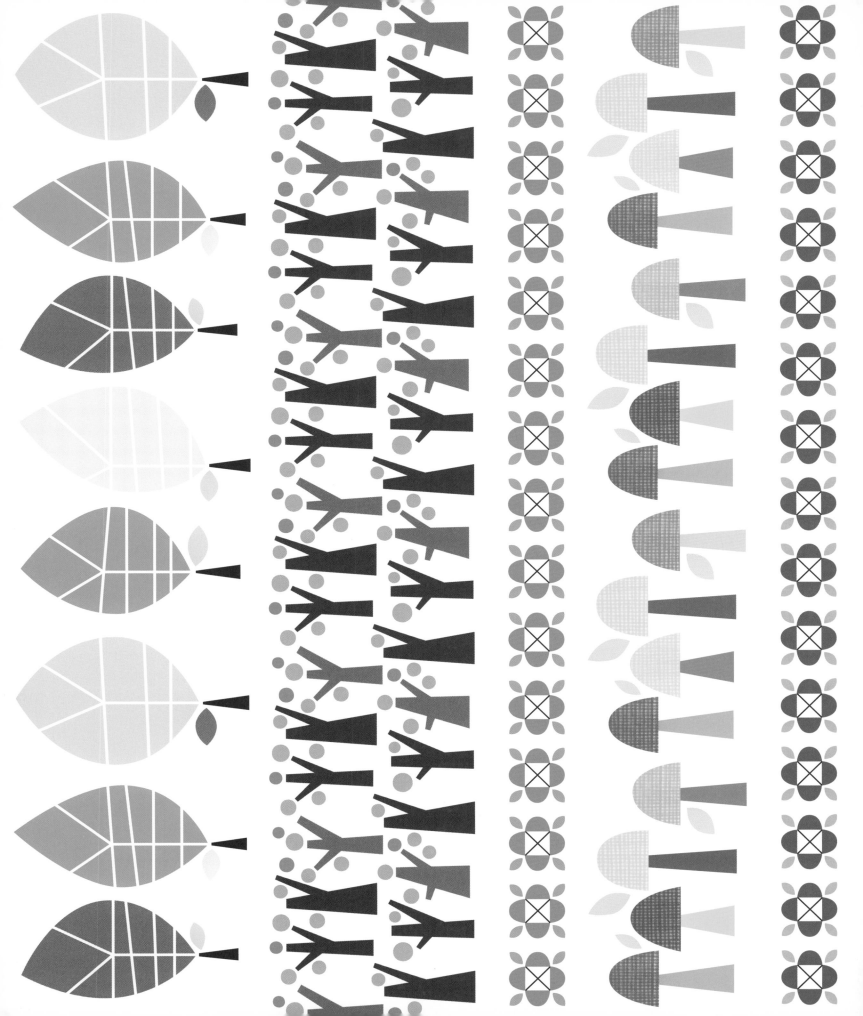

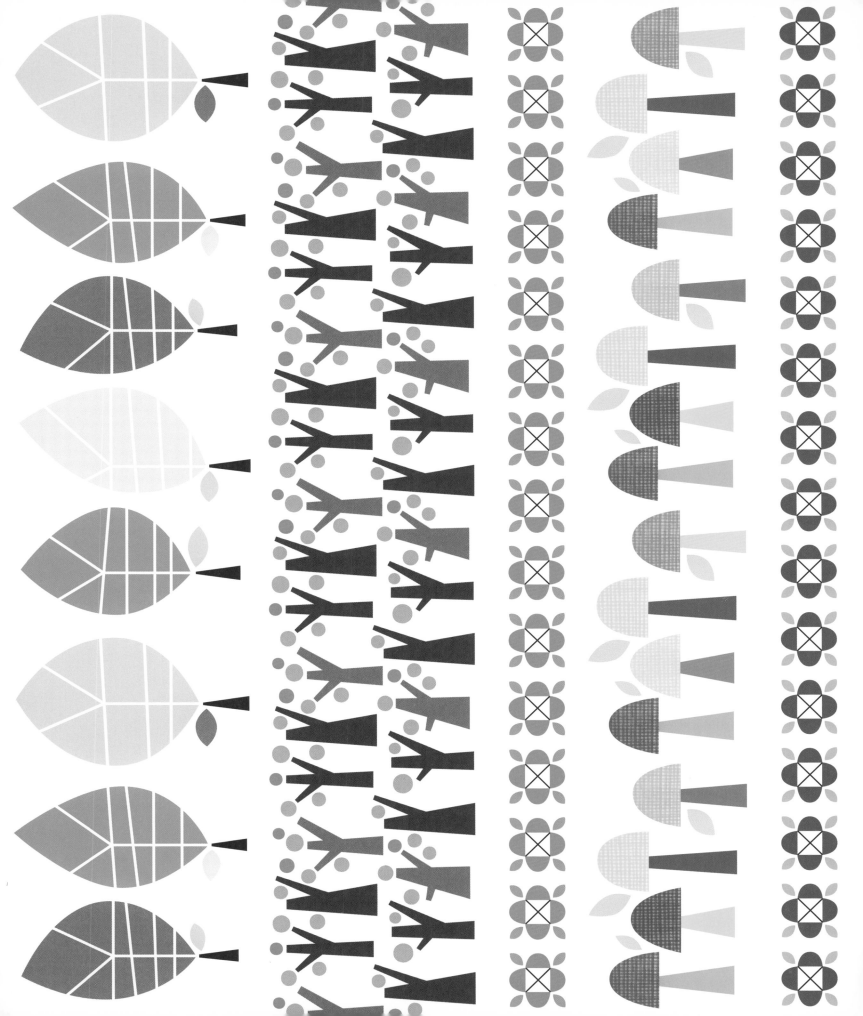

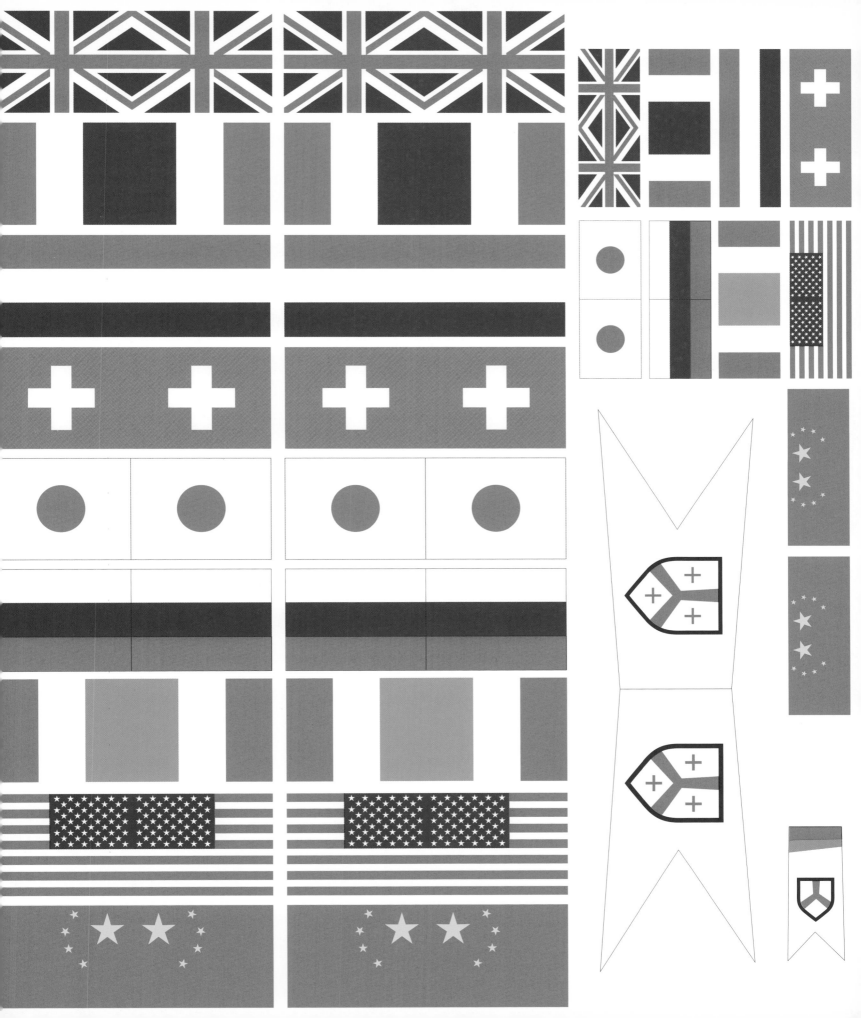

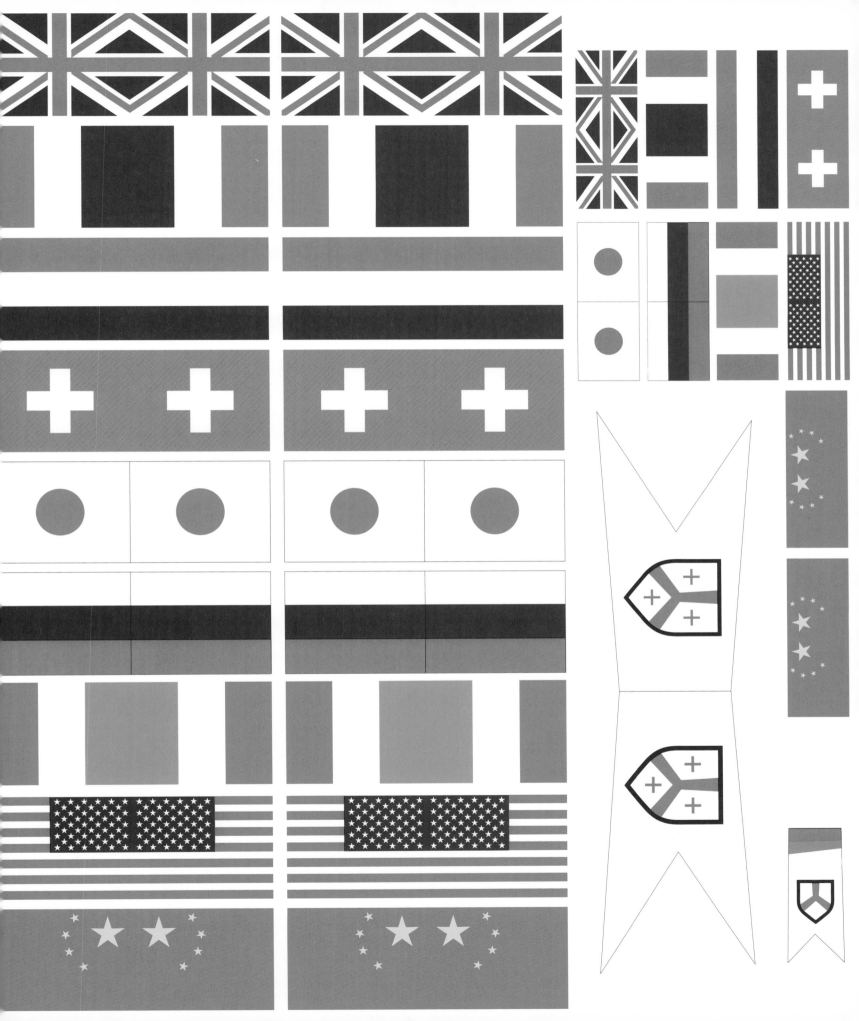

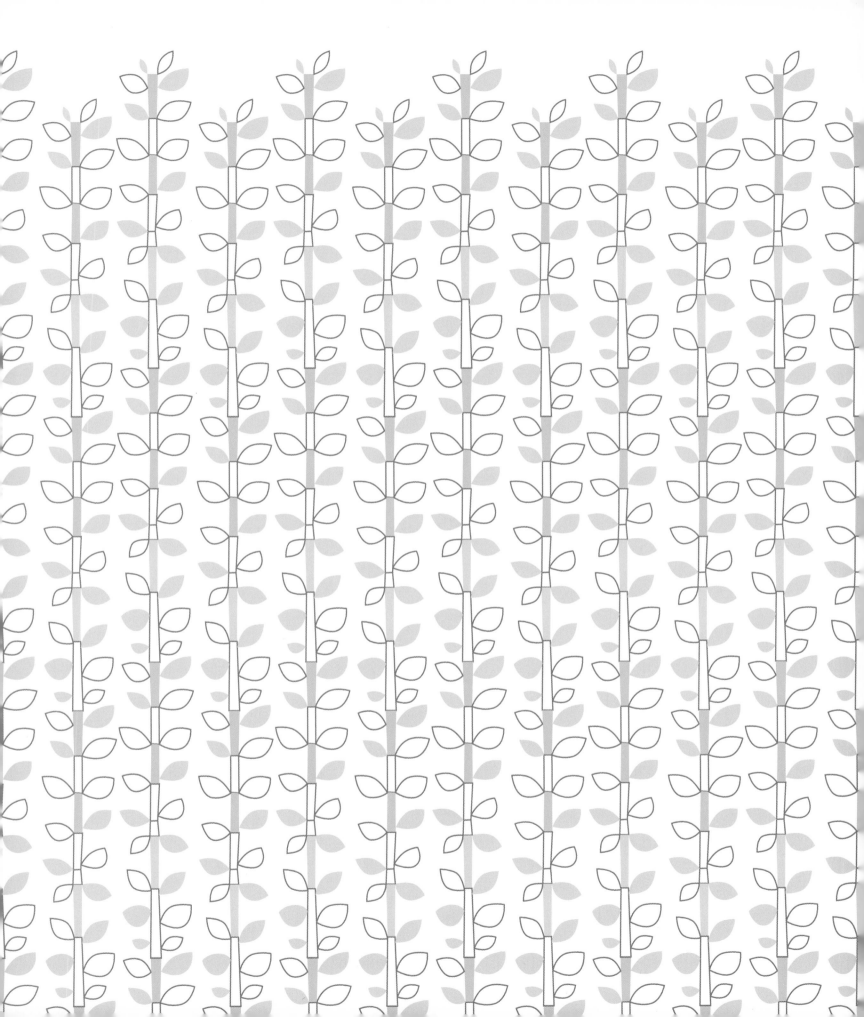

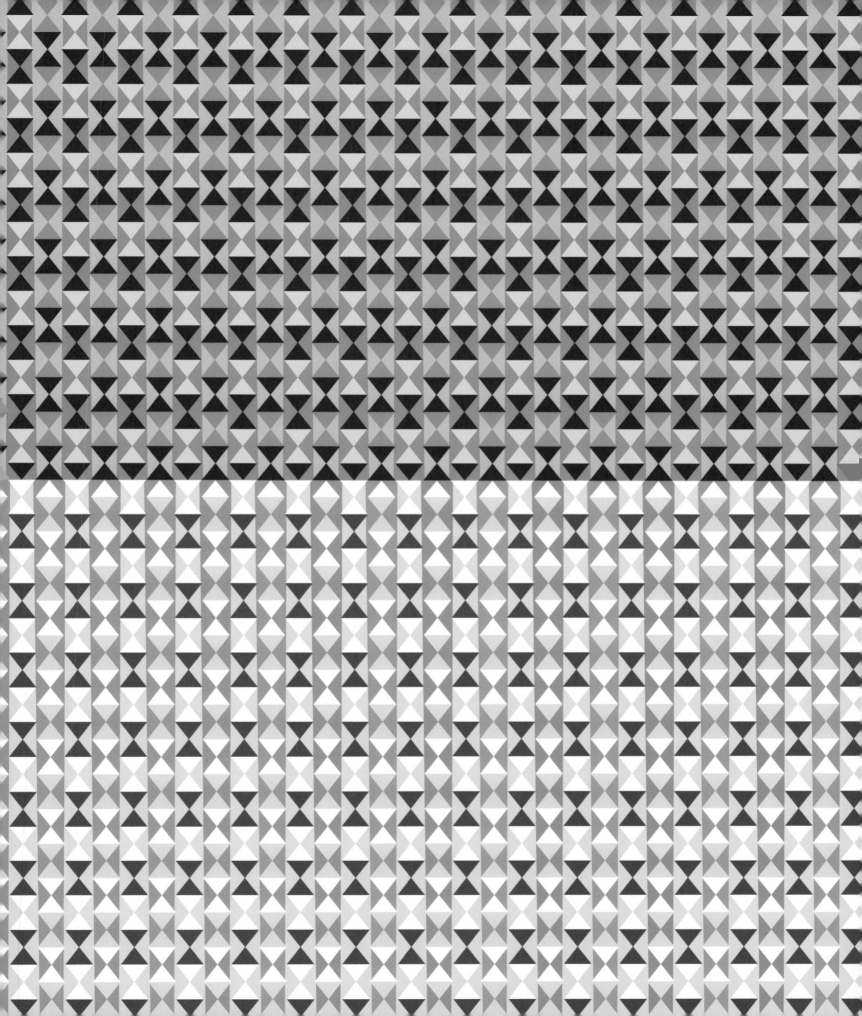

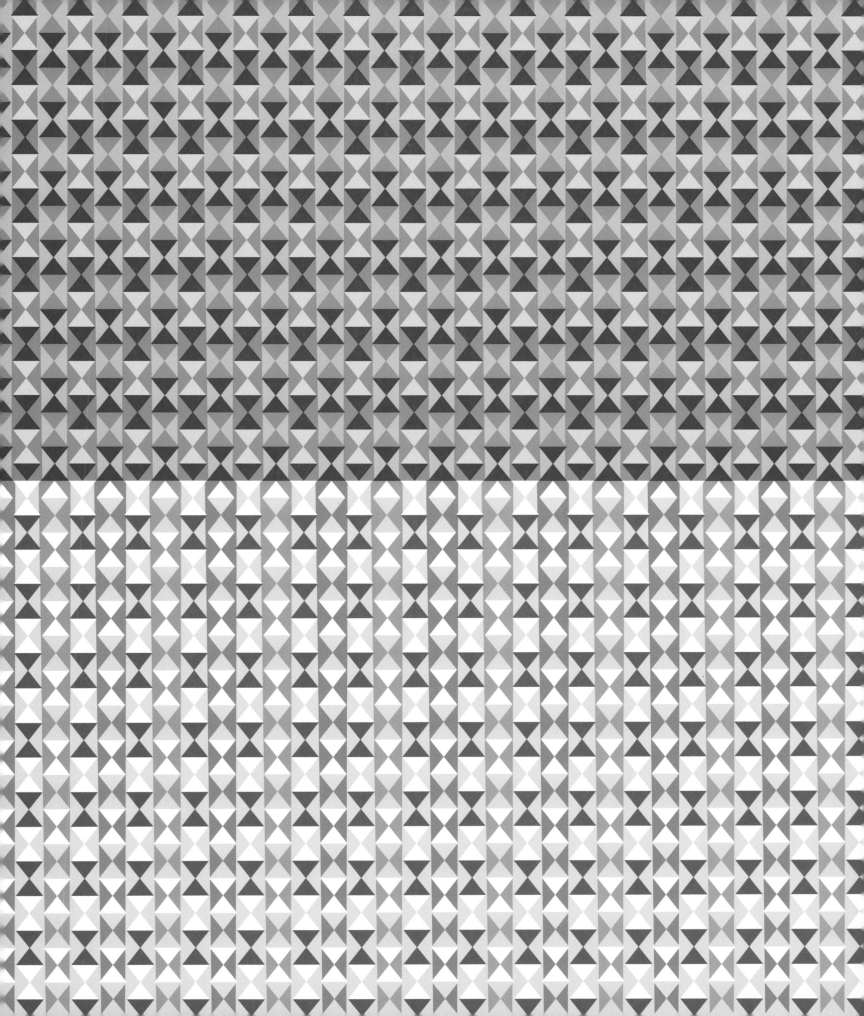

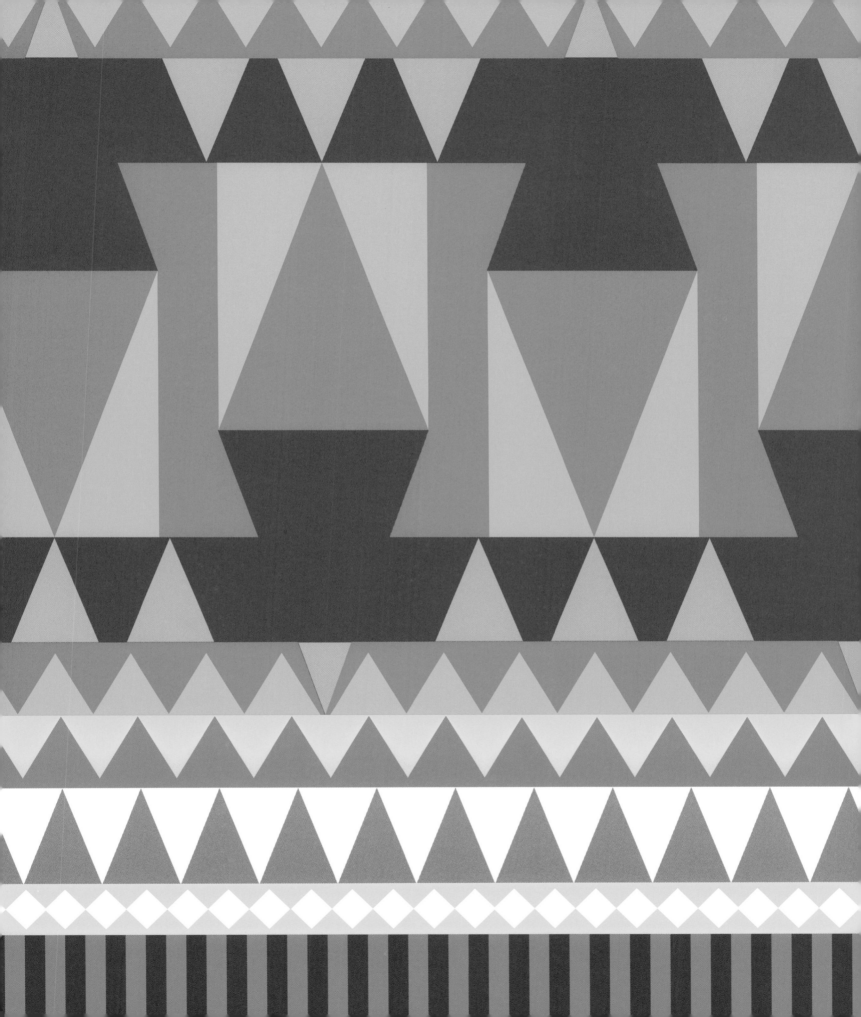

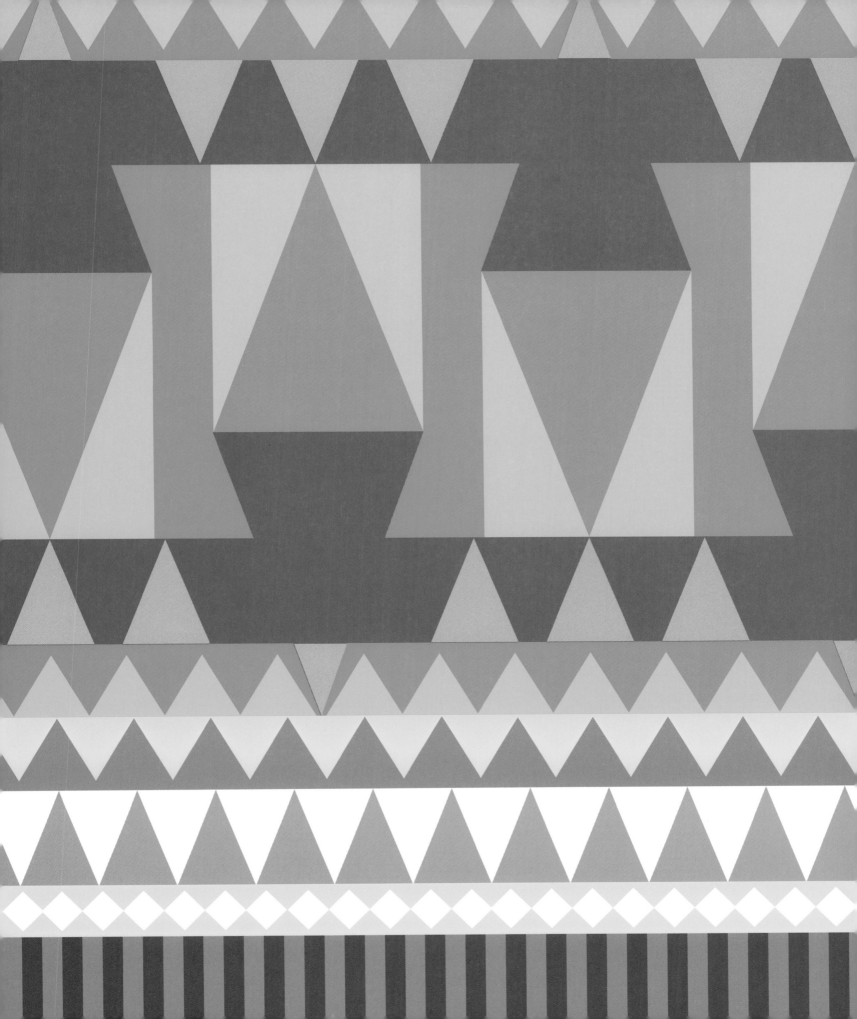

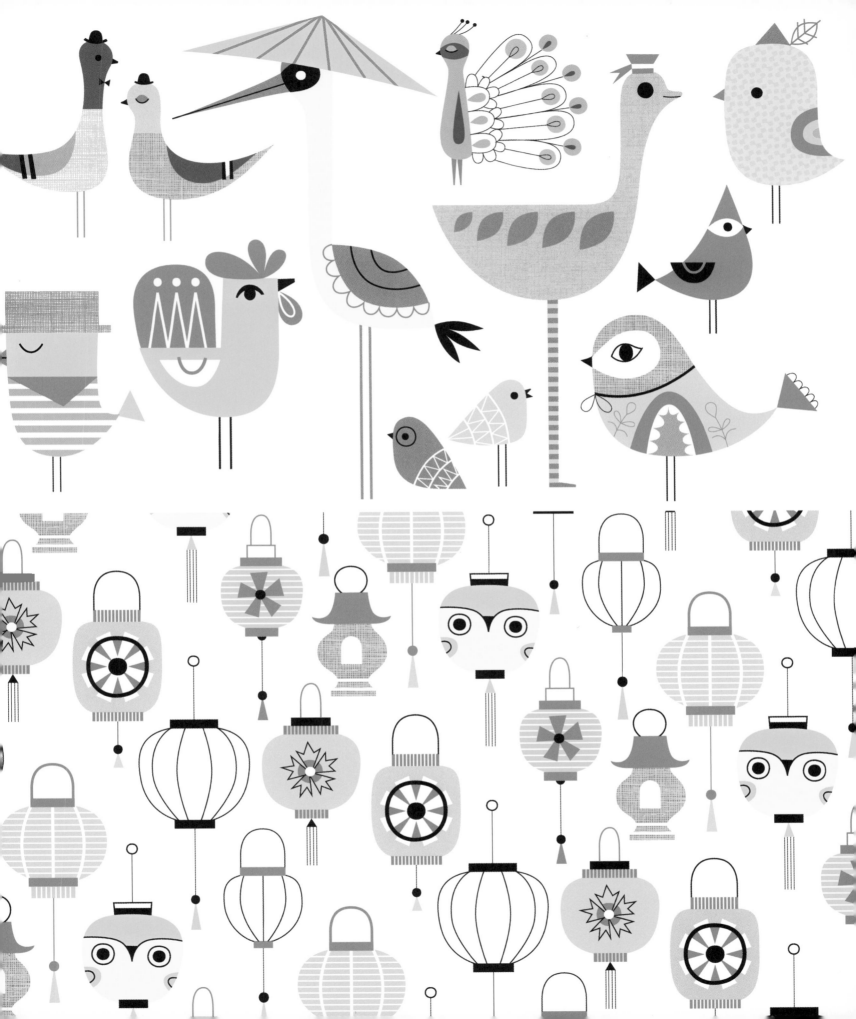

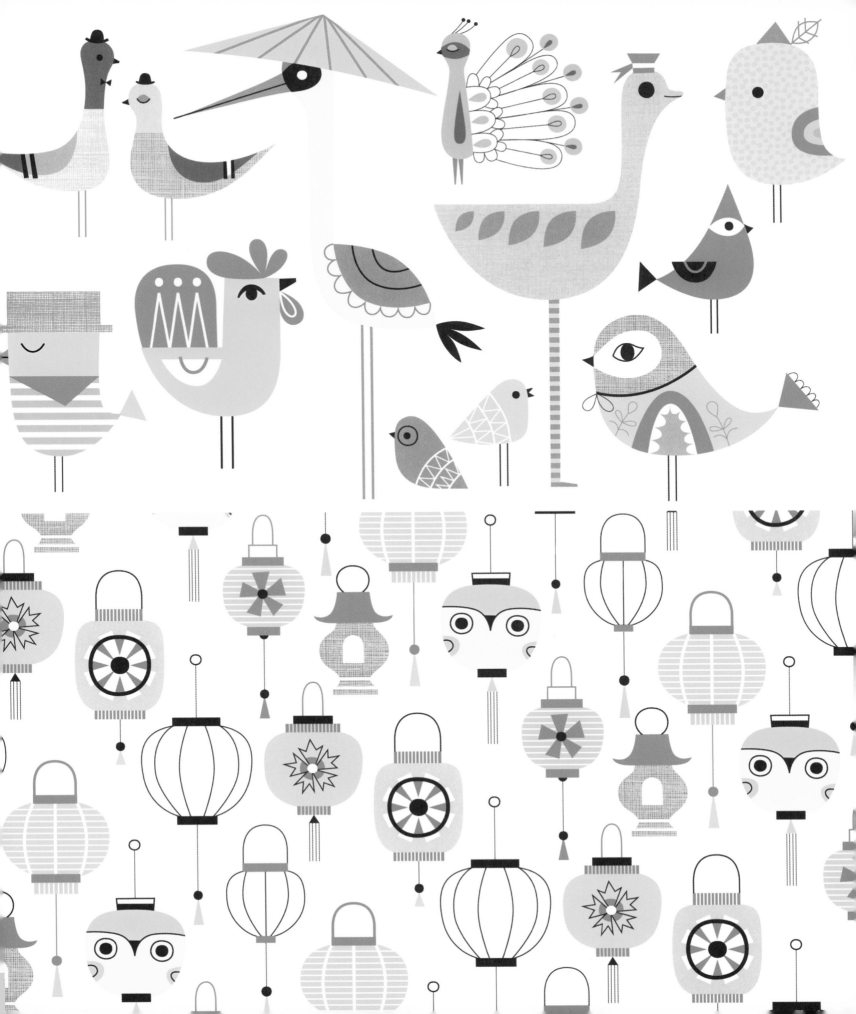

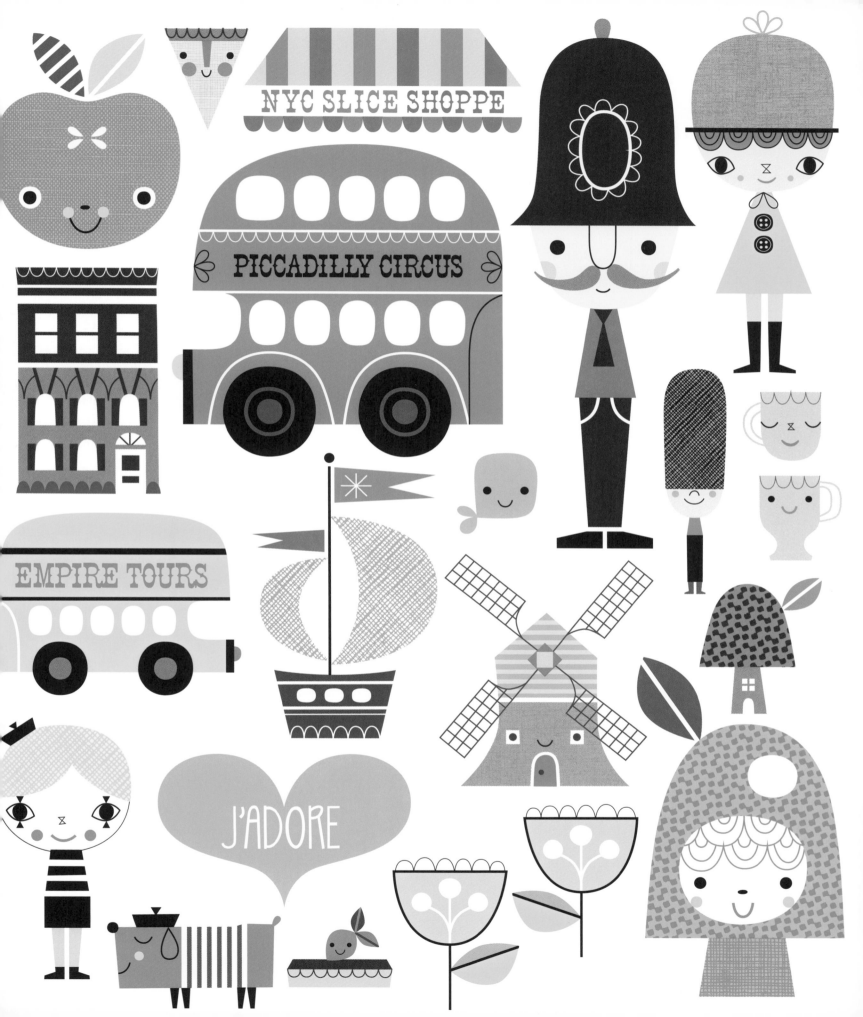

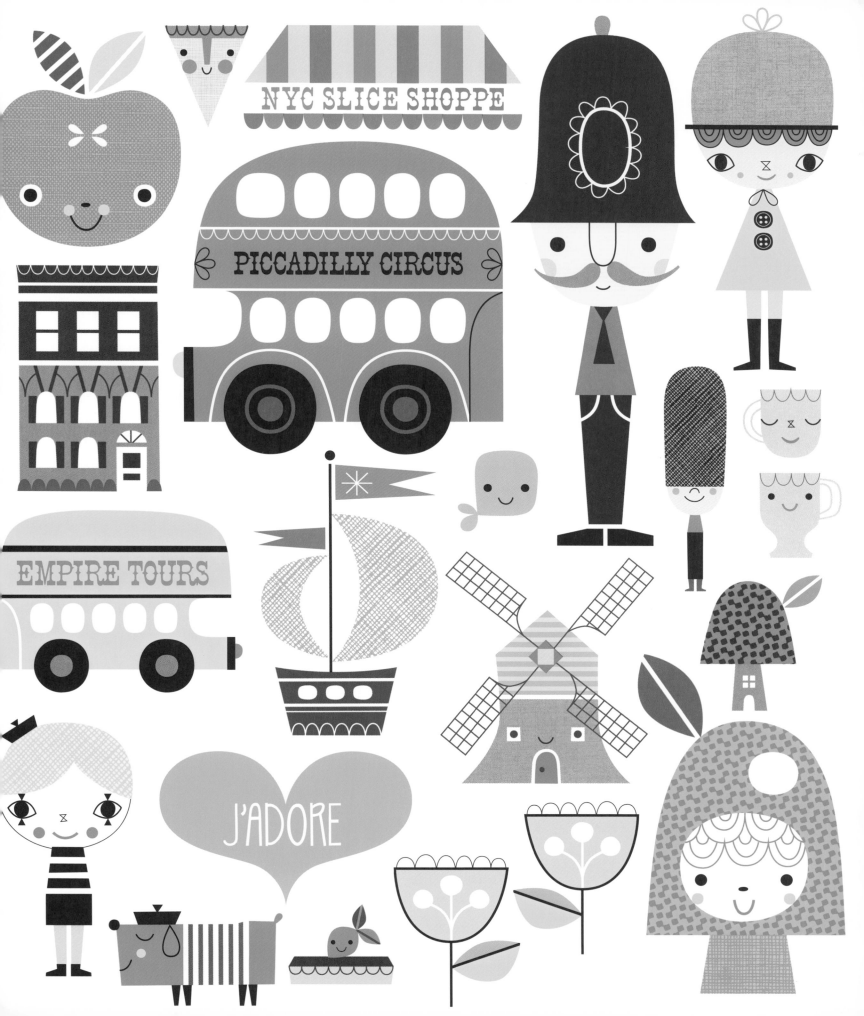

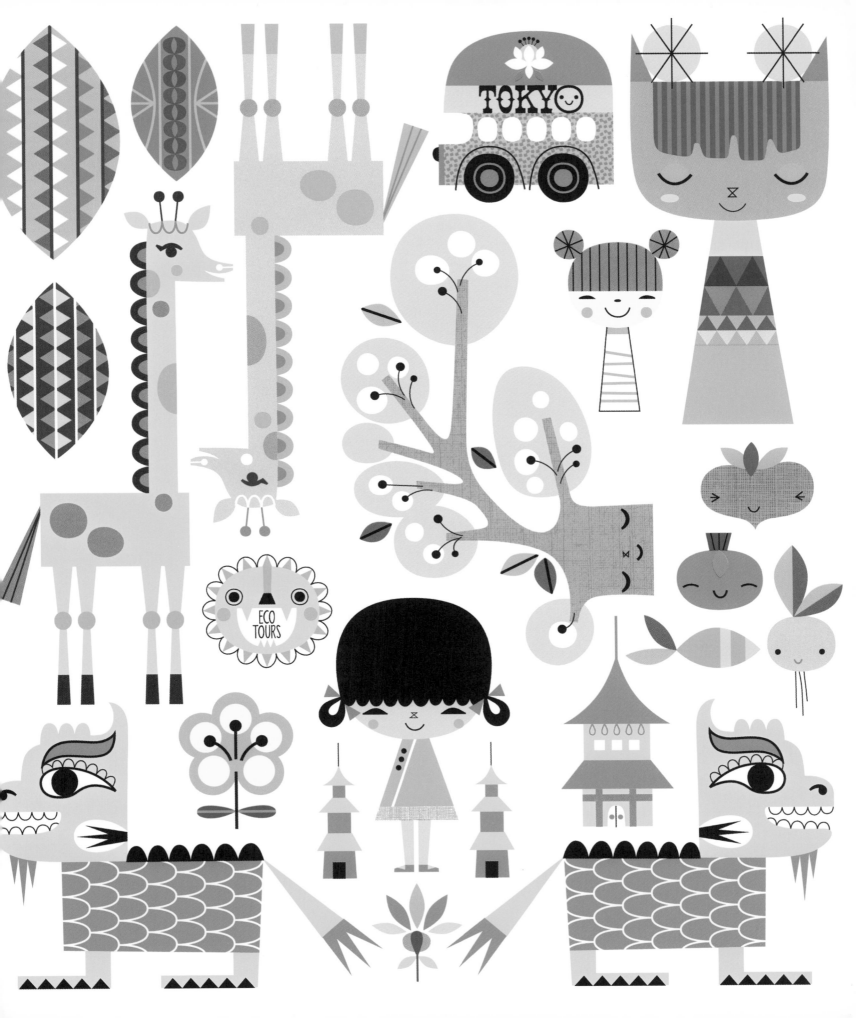

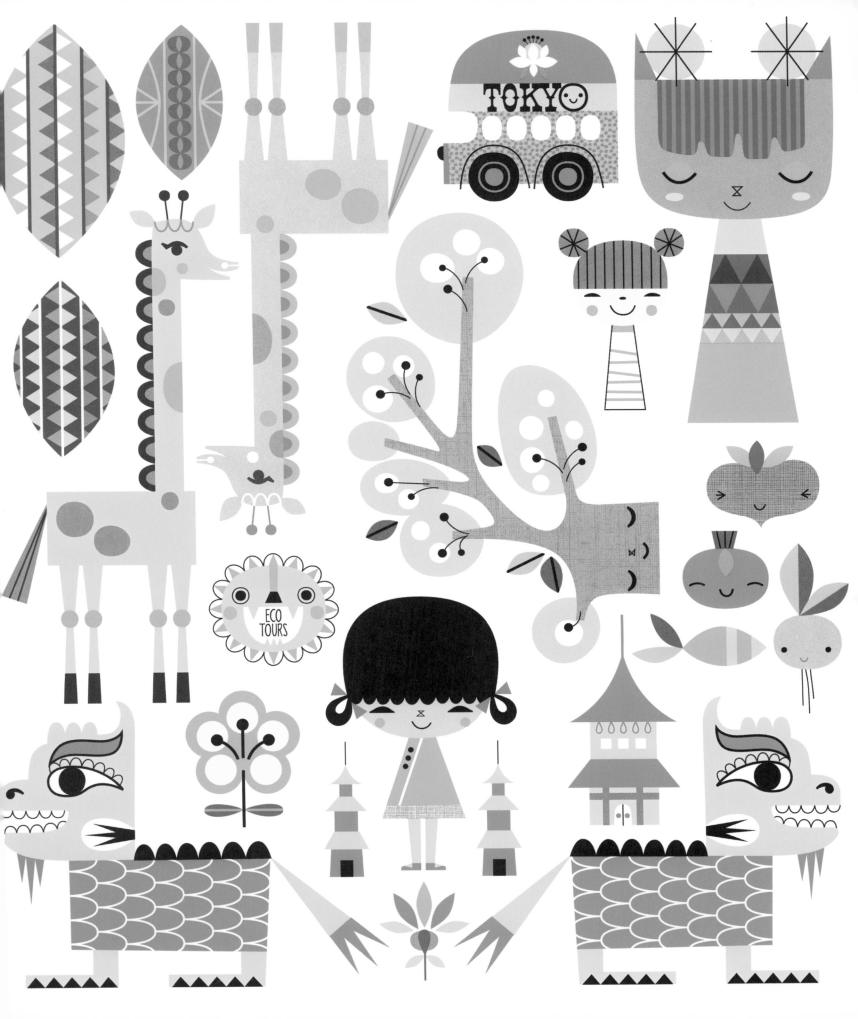